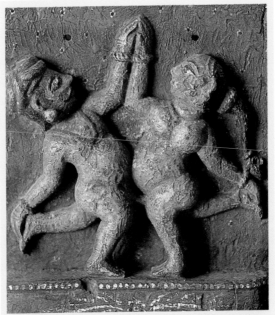

Kamasutra

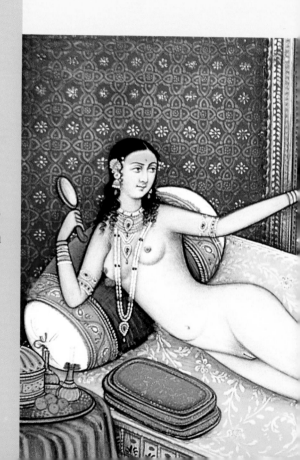

First published by Prakash Books
M-86, Connaught Circus, New Delhi 110001
Ph: (011) 3326897. Fax: (011) 3326566
E-mail: pbdepot@nda.vsnl.net.in

© Prakash Books
© Photographs and Text Tarun Chopra

Designed by: Yogesh Suraksha Design Studio

ISBN : 81-7234-0451

Printed at Thomson Press (I) Ltd.

Prakash Books

Kamasutra

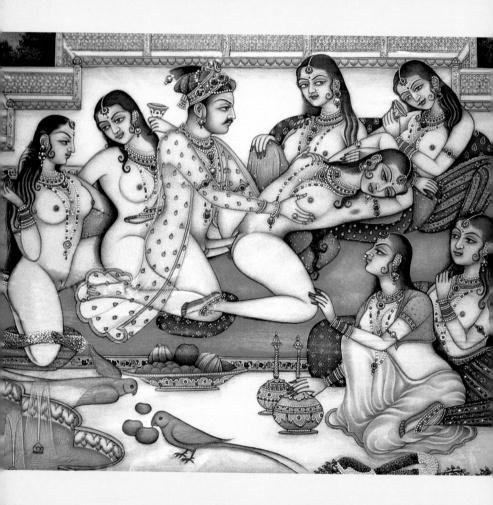

The Kamasutra is perhaps the world's oldest treatise on sex as civilized people practice it. A remarkable document, which gives an insight into the social and political ethos in India 2000 years ago, the Kamasutra, is more than a literary *tour de force*. Indeed, the paucity of written material pertaining to ancient India makes the Kamasutra an important source of information for understanding the world's oldest living civilization.

It is truly remarkable that a detailed study of sexual behavior was done about two thousand years ago. What makes this book even more unique is the fact that many of the observations made by the author, Vatsayana, have withstood the test of time.

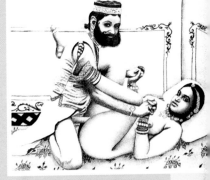

The Kamasutra derives its name from Kamadevta, the Hindu god of love. The text, parts of which date back to the first century of the Christian era contains about one thousand two hundred and fifty slokas or verses, which are divided into seven parts comprising thirty-six chapters.

That kama (love/sex) and religion are two sides of the same coin is depicted with great candor in the great Hindu epics like the Mahabharata. And nothing is left to the imagination if one views the great temples adorned with what is inaccurately labeled 'erotic art'. It must be understood that in the Indian ethos, a very thin line divides sex and religion. In fact, the sexual escapades of the Gods are woven into the rituals and customs of the Hindu religion.

Sexually explicit sculptures are carved on Hindu temples spread across India. The most famous of these temples are at Khajuraho in central India and Konarak on

the eastern coast dating back to the tenth and thirteenth century AD respectively.

In Vedic times, the goals of human life, called *purusharthas*, were codified. They were divided under three heads — *dharma, artha, kama* and collectively known as *trivarga*. Dharma, or righteousness is considered the most important as it is the right conduct of worldly life in accordance to the laws of nature. Artha means collecting worldly comforts and highlights the stage of the *grihasth ashram* (the stage of raising a family) during which one accumulates wealth and property.

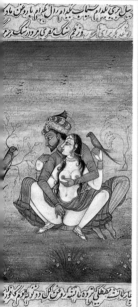

The Kamasutra dwells on the third purushartha, viz kama, or sexual desire that is central to the evolution of the mankind. Here the law states that intercourse should be more than just an action to procreate — maximum pleasure should be derived from it. However, it should be enjoyed in moderation.

The Preparations

When a person fails to obtain the object of his desire in the normal course, he should then have recourse to other ways of attracting a woman. Indeed, in the absence of good looks, qualities, youth and liberality, a man or woman must have to resort to artificial means or to art by using certain recipes to make one more appealing.

The use of ointments made from the extract of plants like the hogweed, sarina and yellow amarnath makes a person look attractive. Eating the powder of the blue lotus with ghee and honey has a wondrous effect. Similarly, amulets made of the bone of peacock or hyena covered with gold and tied on the right hand makes a man lovely in the eyes of others. Besides, magic

incantations from the Arthava Veda enhance the effect.

For her part, a woman should be well versed in the art of singing, playing musical instruments, dancing, writing and drawing, tattooing, spreading and arranging beds or couches of flowers, coloring the teeth, garments, nails and body, wearing jewelry, the art of mimicry or imitation and the art of applying perfumed ointments to the body and of dressing the hair with lotions and perfumes and braiding it. Even the bare knowledge of these arts, among other esoteric skills, makes a woman attractive though the practice of these arts may be possible only according to the circumstances of each case.

Foreplay

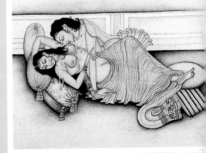

Any sexual union begins with the embrace. There are four basic embraces. When a man on some pretext touches the woman's body as a prelude to a sexual union, it is called the 'touching embrace'. When a woman bends down, as if to pick up something and pierces, as it were, a man sitting or standing, and the man in return takes hold of them, it is called a 'piercing embrace'. When two lovers rub their bodies against each other, they indulge in a 'rubbing embrace'. And when one of them presses the other's body against a wall or pillar, it is called a 'pressing embrace'. The two last embraces are specific to those who know the intentions of each other.

It is said by some that there is no fixed time or order between the embrace, the kiss and the pressing and scratching with the nails or fingers but that all these things should be done generally before sexual union takes place. Vatsayana, however, thinks

that any of these functions may take place at any time for love does not care for time or order.

On the occasion of the first meeting, kissing and the other forms of foreplay mentioned above should be done in moderation. Besides, they should not be continued for a long time and should be done alternately. On subsequent occasions, however, the reverse of all this may take place and moderation is not necessary. In fact, they may all be done at the same time.

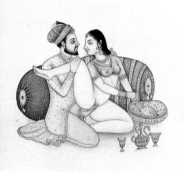

There are three variations of the kiss: A 'nominal kiss' is when a woman touches only the mouth of her lover with her own but does not do anything herself. But when a women sets aside her shyness and touches the lip that is pressed into her mouth, and with that object moves her lower lip, but not the upper one, she gives a 'throbbing kiss'. When a woman touches her lover's lip with her tongue, and having shut her eyes, places her hands on those of her lover, she gives a 'touching kiss'.

When passion becomes intense, pressing with the nails or scratching the partner's body with them is done on the following occasions — on the first visit; at the time of setting out on a journey; on the return from a journey; at the time when an angry lover is reconciled; and lastly when the woman is intoxicated.

Biting, which consists of unequal risings in a circle, and which comes from the space between the teeth, is called the 'broken cloud'. This is impressed on the breasts. Biting which consists of many broad rows of marks near to one another, and with red intervals is called the 'biting of a boar'. These are impressed on the breasts and the

shoulders and these methods of biting are peculiar to persons with intense passion.

Sexual Union

There are nine kinds of union which are classified in terms of dimension, force of passion and duration respectively. By using different combinations, innumerable kinds of union can be produced. Therefore, in each particular kind of sexual union, men should use such means as they may think suitable for the occasion.

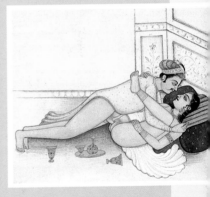

Man is divided into three categories — the hare man, the bull man and the horse man — according to the size of his *lingam*, or penis. The woman, going by the depth of her *yoni*, or vagina, is a female deer, a mare or a female elephant. Thus there are three equal unions between the persons of corresponding dimensions.

Similarly, there are six unequal unions. In these unequal unions, when the male exceeds the female in size, his union with a woman who is immediately next to him in size is called high union; while his union with the woman most remote from him in size is called the highest union.

On the other hand, when the female exceeds the male in size, her union with a man immediately next to her in size is called low union, while her union with a man most remote from her in size is called the lowest union, In other words, the horse and mare or the bull and deer form the high union, while the horse and deer form the highest union. For the female, the elephant and bull or the mare and hare form low unions, while the elephant and hare make the lowest unions. Among all these, equal

unions are the best and those of a superlative degree, that is, the highest and lowest, are the worst. The rest are average and with them the high union is better than the low union.

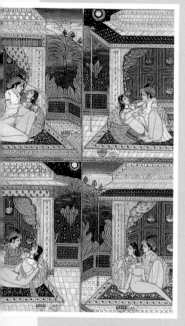

There are also nine kinds of union according to the form of passion or carnal desire. A man whose desire during intercourse is not great, whose semen is scanty, and who cannot bear the warm embraces of his partner is called a man of small passion. Those who differ from this temperament are called men of average passion, while those of intense passion are full of desire. Similarly, women are supposed to possess the three degrees of feelings as men.

Lastly, in a time frame of a sexual union there are three kinds of women: the short-timed, the moderate-timed, and long-timed. Here, too, there are nine kinds of union.

At the first time of sexual union the passion of the male is intense and his time is short, but in subsequent unions on the same day the reverse is the case. With the female, however, the opposite is the case for at the first time her passion is weak and her time long, but on subsequent occasions on the same day her passion is intense and her time short until her passion is satisfied.

Ideal Positions For A Cosmic Orgasm
On the occasion of a 'high sexual union' the *mrigi* (deer) woman should lie down in

such a way as to widen her yoni, while in a 'low union' the hastini (elephant) woman should lie down so as to contract it. But in an 'equal union' they should lie down in the natural position. What is said above concerning the mrigi and the hastini applies to the *vadawa* (mare) woman as well. In a 'low union' the woman should particularly make use of aphrodisiacs to cause her desires to be satisfied quickly.

The deer-woman has the following three ways to position herself: When she lowers her head and raises her middle parts, she is in the 'widely opened position'. At such a time the man should apply some lubricant to make penetration easy.

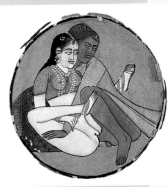

When she raises her thighs and keeps them wide apart or when she raises both legs and places them on her lover's shoulders she is in the 'yawning position'. And when she places her thighs with her legs doubled up on her sides she takes the 'position of Indrani' which is only perfected through practice. This position is also useful in the case of the highest sexual union.

When the legs of both the male and the female are stretched straight out over each other, they are in the 'clasping position'. This is of two kinds — the side position and the supine position depending on the manner in which they lie down. In the side position the male should invariably lie on his left side and make the woman to lie on her right side. This rule is to be observed in lying down with all kinds of women.

After penetration has been achieved, the woman presses her lover with her thighs in the 'pressing position'. When the woman places one of her thighs across the thigh of her lover she embraces him in the 'twining position'. And if she forcibly holds the

lingam in her yoni, it is called the 'mare's position'.

Vatsayana also explains other positions for the ultimate in lovemaking. For example, when the female raises both her thighs straight up, she employs the 'rising position'. And when her legs are contracted and held by the lover before his chest, it is called the 'pressed position'.

At a more advanced stage of lovemaking, when the woman places one of her legs on her lover's shoulder and stretches the other out and continues to do so alternately,

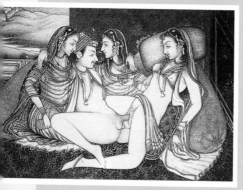

she is in a position called the 'splitting of a bamboo'. Going to a higher level, when one of her legs is placed on the head of her lover and the other is stretched out, it is called the 'fixing of a nail'. This requires practice. When both the legs of the woman are contracted and placed on her stomach, it is called the 'crab's position'. When the shanks are placed one upon the other the 'lotus position' is achieved. If, during intercourse, the man turns round and enjoys the woman without leaving her, while she embraces him round the back all the time, he performs the 'turning position'.

These different ways of lying down, sitting and standing should be practiced in water because then it is easy to master the complicated positions. In this case, the man supports himself against a wall and the woman, sitting on his hands joined together and held underneath her, throws her arms round his neck, puts her thighs along his waist and moves herself by her feet which are touching the wall against which the man is leaning. This is called the 'suspended position'.

When a woman stands on her hands and feet like a quadruped, her lover mounts her like a bull to achieve the 'congress of a cow'. At this time everything that is ordinarily done on the bosom should be done on the back.

When a man enjoys two women at the same time, both of who love him equally, it is a state of 'united union'. And when he enjoys many women together he executes a 'union of a herd of cows'.

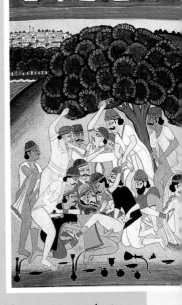

Many young men can enjoy a woman who may be married to one of them, either one after the other, or at the same time. Thus one of them holds her, another enjoys her, a third uses her mouth, a fourth holds her middle part, and in this way they go on enjoying her several parts alternately. The same things can be done when several men are sitting in the company of one courtesan. Similarly, the women of the king's harem can do this when they accidentally get hold of a man.

A Woman in A Man's Role

When a woman sees that her lover is fatigued by constant sex without having his desire satisfied, she should lay him down and act his part. She may also do this to satisfy the curiosity of her lover or her own desire of novelty.

There are two ways of doing this. The first is when during congress she turns round, and gets on the top of her lover, in such a manner as to continue intercourse without disturbing the pleasure of the moment. The other is when she acts the man's

part from the beginning. On such occasions, with flowers in her hair hanging loose and her smile broken by hard breathing, she should press upon her lover's bosom with her breasts, lowering her head frequently. In short, she should do in return the same actions that he did earlier.

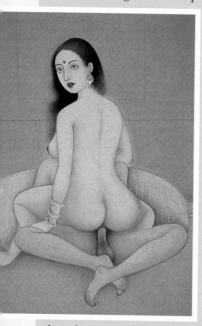

When a woman acts the part of a man, she should do the following things in addition to the ones given above: When the woman holds the lingam in her yoni, draws it in, presses it, and keeps it thus in her for a long time, she uses a 'pair of tongs'.

When, while engaged in intercourse, she turns round like a wheel, she becomes the 'spinning top'. This is learnt by practice only. When, on such an occasion, the man lifts up the middle part of his body and the woman turns round her middle part, they perform the 'swing'.

When the woman is tired, she should place her forehead on that of her lover and should rest without disturbing the union of the organs. When she has rested, the man should turn round and begin the union again.

A woman by nature is reserved and keeps her feelings concealed but when she gets atop a man, she shows all her love and desire. A man should gather from the actions of the woman of what disposition she is and in what way she likes to be enjoyed. However, a woman having her monthly periods, a woman who has been bedridden with illness, and a fat woman should not act the part of a man.

Man's Work Is Cut Out For Him

While the woman is lying on his bed and distracted by his conversation, the man should loosen the knot of her undergarments. If she begins to resist, he should overwhelm her with kisses. Then when his lingam is erect he should touch her with his hands in various places and gently manipulate various parts of her body. If the woman is shy and if it is the first time that they have come together, the man should place his hands between her thighs, which she would probably keep close together. If she is a very young girl, he should first get his hands upon her breasts which she would probably cover with her own hands, and under her armpits and on her neck. If, however, she is a seasoned woman, he should do whatever is agreeable either to him or to her. After this he should take hold of her hair and hold her chin in his fingers for the purpose of kissing her. Anyway, he should gather from the actions of the woman what things would be pleasing to her during the union.

The signs of the enjoyment and satisfaction of the woman are as follows: Her body relaxes, she closes her eyes, she puts aside her shyness and shows increased willingness to unite the two organs as closely together as possible. On the other hand, the signs of her want of enjoyment and of failing to be satisfied are as follows: She shakes her hands, she does not let the man get up, feels dejected, bites the man, kicks him, and continues to go on moving after the man has finished. In such cases the man should rub the yoni of the woman with his

hand and fingers (as the elephant rubs anything with his trunk) before engaging in intercourse until it is softened and after that is done he should proceed to put his lingam into her.

When the organs are brought together properly and directly it is called 'moving the organ forward'. When the lingam is held with the hand and turned all round in the yoni is called the 'churning'. When the yoni is lowered and the upper part of it is struck with the lingam, it is called 'piercing'. But when the lingam is removed to some distance from the yoni and then forcibly strikes it, it is called 'giving a blow'.

When only one part of the yoni is rubbed with the lingam, it is called the 'blow of a boar'. On the other hand, when the lingam is in the yoni and moved up and down frequently, and without being taken out, it is called the 'sporting of a sparrow'. This takes place at the end of the sexual union.

While concluding, Vatsayana offers a word of caution. "This work is not to be used merely as an instrument for satisfying our desires. A person acquainted with the true principles of this science, who preserves his Dharma (virtue or religious merit), his Artha (worldly wealth) and his Kama (pleasure or sensual gratification), and who has regard to the customs of the people is sure to obtain the mastery over his senses. In short, an intelligent and prudent person, attending to Dharma and Artha, and attending to Kama also, without becoming the slave of his passions, obtains success in everything that he may undertake."

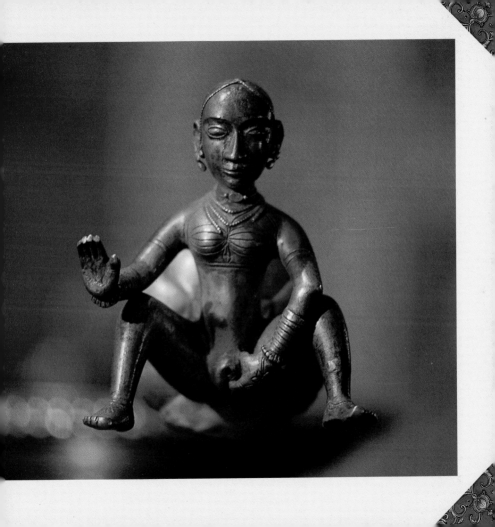

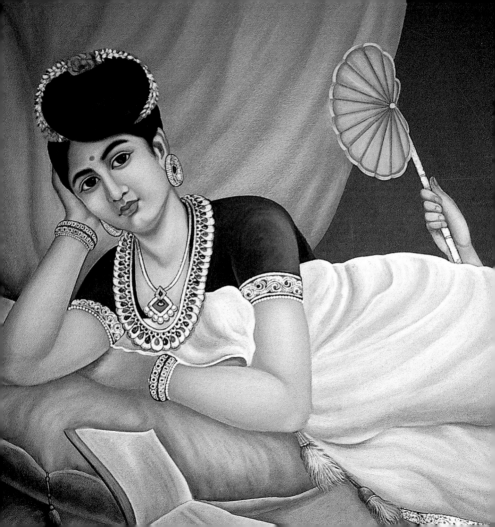

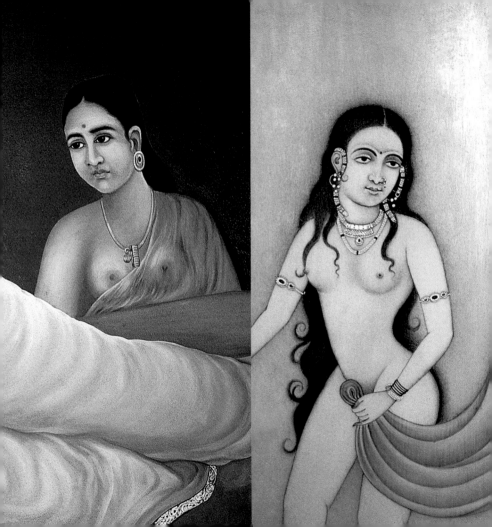

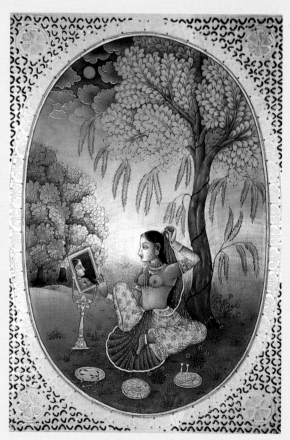

A woman must know the art of dressing her hair (above) Good looks, qualities and youth are necessary to make a person agreeable in the eyes of others (previous page) There is no fixed time or order between the embrace, kiss and pressing of the nails before union for love does not care for time or order (facing page)

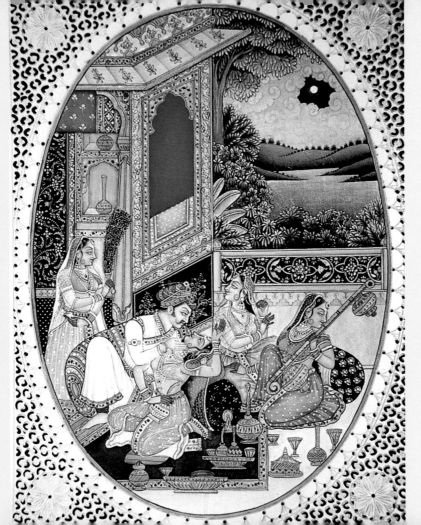

21

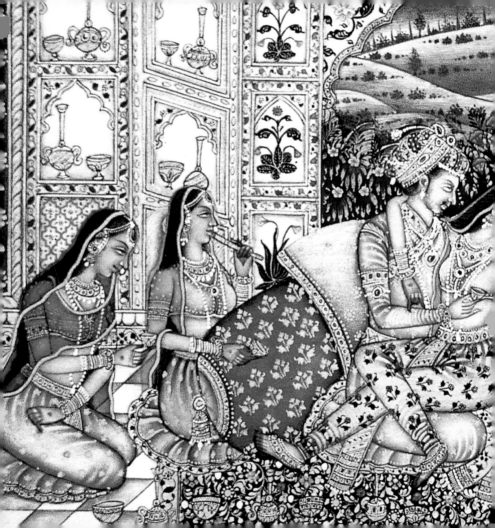

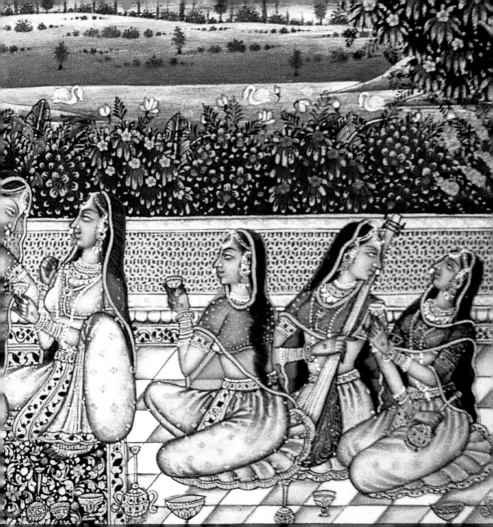

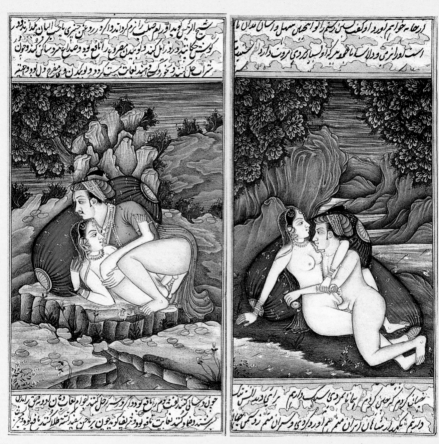

After penetration, the woman holds her lover with her thighs in the 'pressing position' (above left) Lovers in the 'clasping position' (above right) Among all unions, the 'equal union' is the best (facing page left) A man mounts a woman like a bull to achieve the 'congress of a cow' (facing page right)

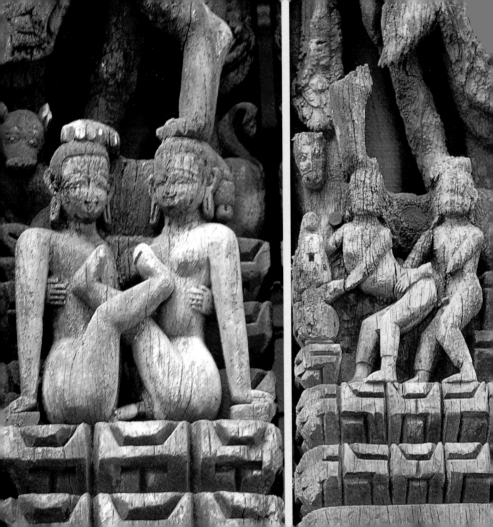

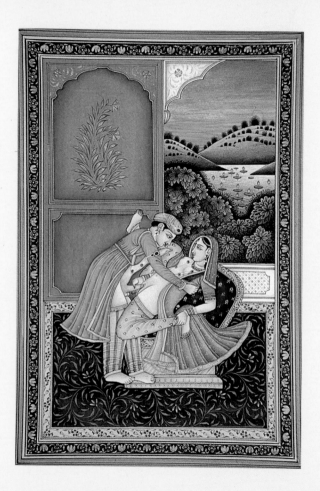

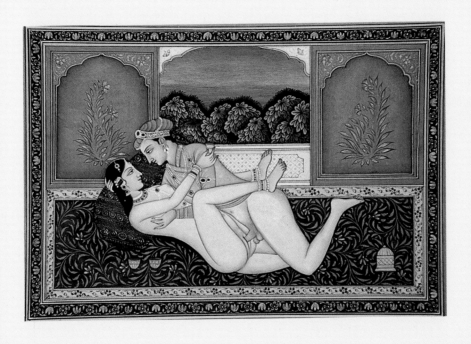

Placing the shanks one upon the other forms the 'lotus position' (above)...
When a woman places her thighs with her legs doubled on them she takes the 'position of Indrani' which requires practice (facing page)

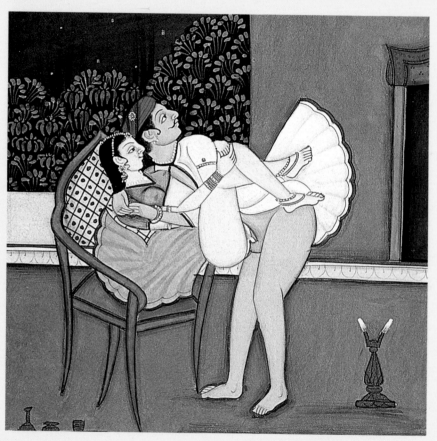

In the 'suspended position' sexual union is achieved with the man standing and the woman throws her arms around her lover's neck and her thighs along his waist

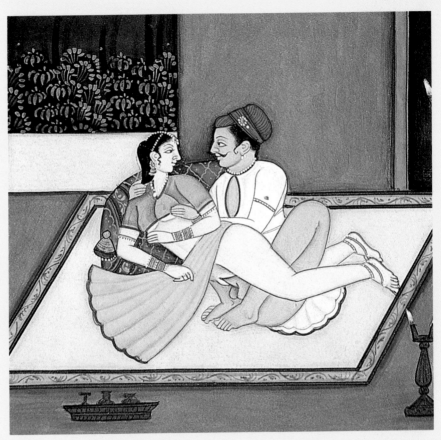

During intercourse, if the man turns around and enjoys the woman without leaving her, while she embraces him, he performs the 'turning position'

29

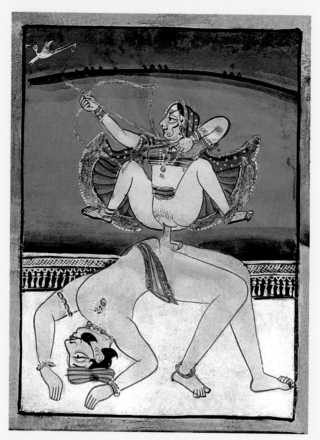

When a woman is engaged in intercourse and turns around like a wheel, she becomes the 'spinning top' (above)
When the man lifts the middle part of his body and the woman turns round her middle part, the position is called
'the swing' (facing page)

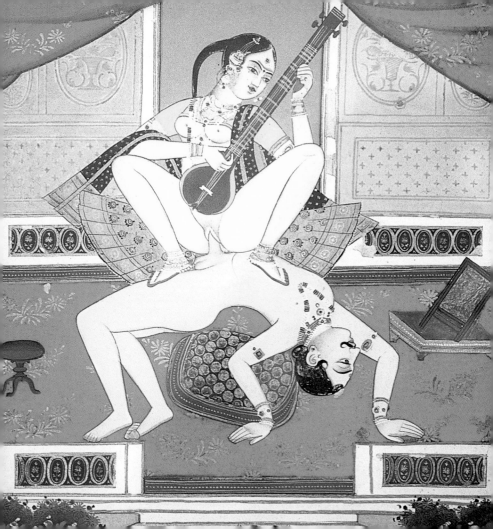

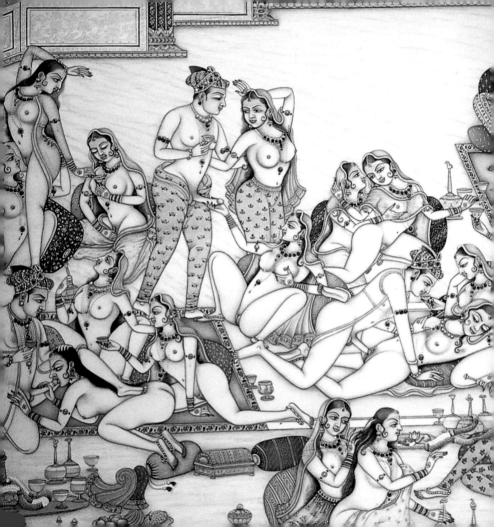

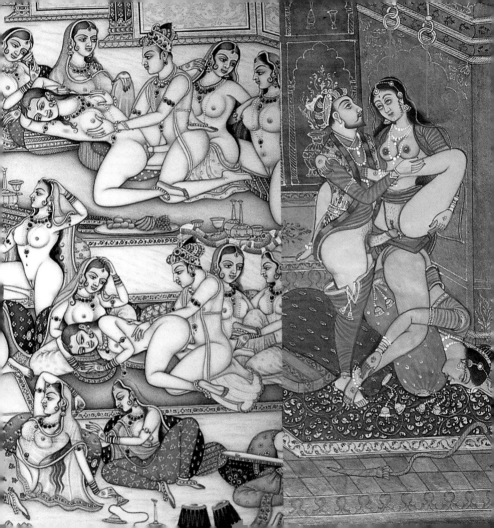

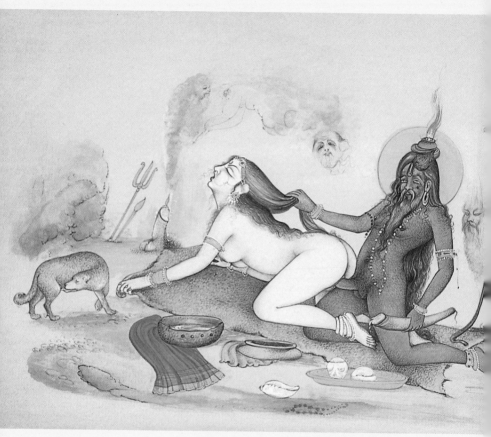

In the Indian ethos, a very thin line divides sex and religion. In fact the sexual deeds of the gods are woven into Hindu ritual and custom (above) The woman places one of her thighs across the thigh of her lover in the 'twining position' (facing page)

34

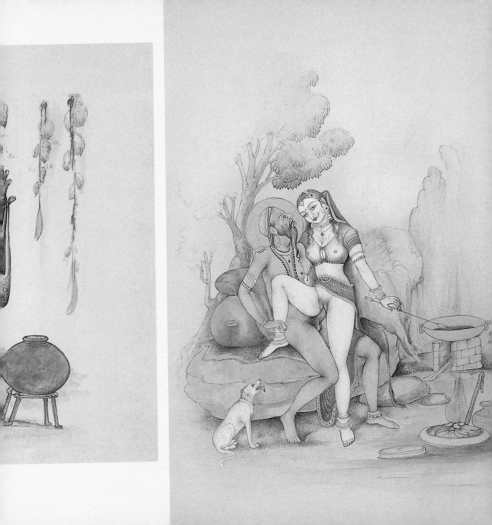

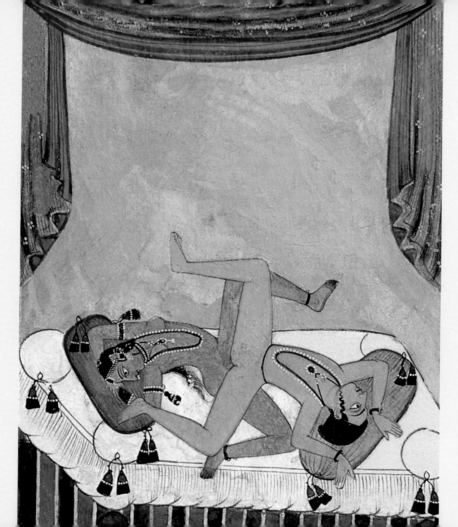

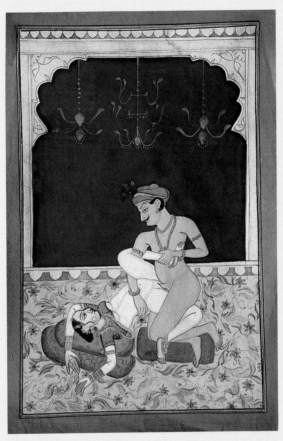

The deer woman lowers her head and raises her middle parts in the 'widely opened position', but when she raises her legs she is in the 'yawning position' (above) The man turns around without leaving the woman in the 'turning position' (facing page)

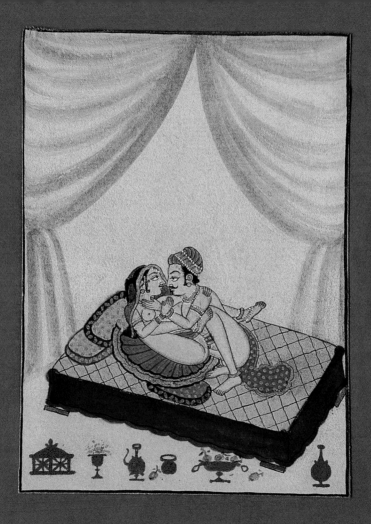

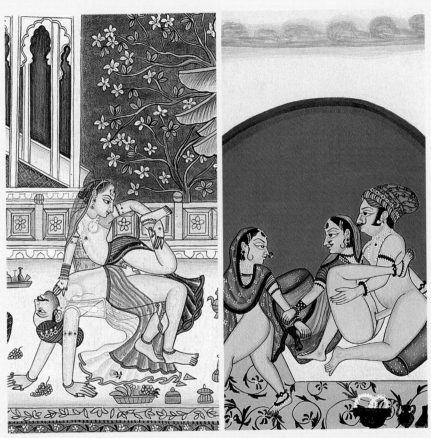

Holding the lingam in the yoni for a long time is called the 'pair of tongs' (above left) The woman places one of her legs on the shoulder of her lover alternately to perform the 'splitting of the bamboo' (above right) The woman raises her thighs and keeps them wide open in the 'yawning position' (facing page)

39

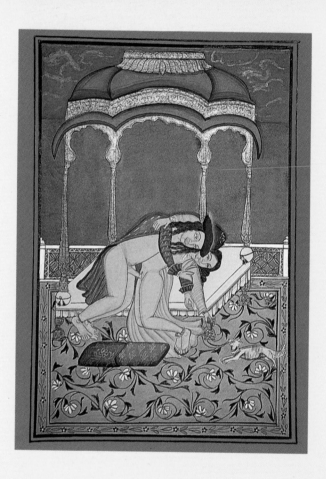

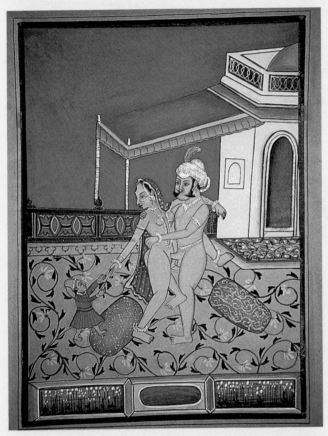

Man is divided into three categories – the hare man, the bull man and the horse man according to the size of his lingam. The woman, going by the depth of her yoni, is a female deer, a mare or a female elephant. Thus there are three equal unions between the persons of corresponding dimensions

41

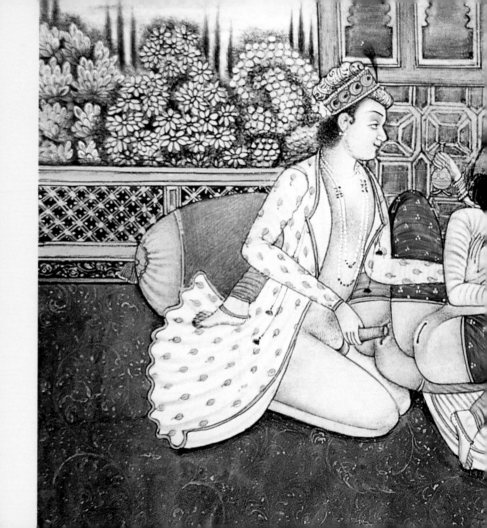

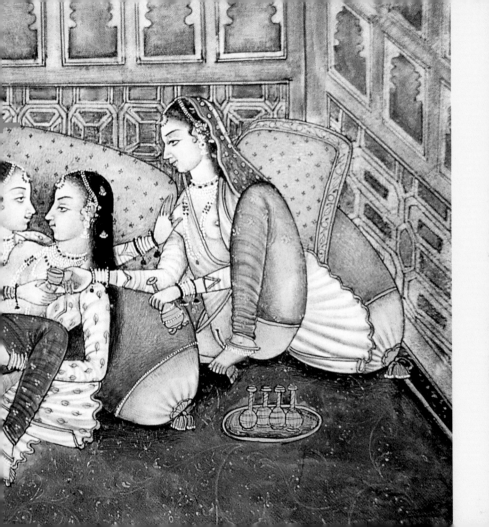

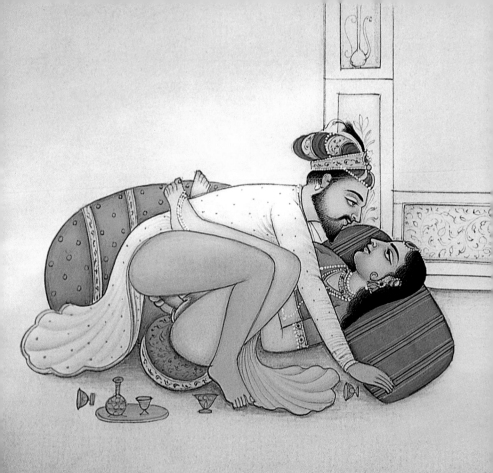

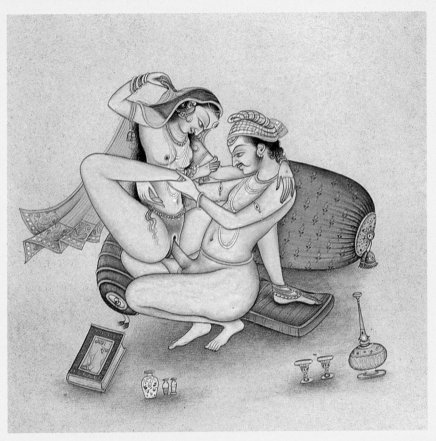

When the woman places one of her legs on her lover's head while the other is stretched out, she is 'fixing the nail'
(above) By raising her thighs the woman employs the 'rising position' (facing page) When a man enjoys many
women together he executes a 'union of a herd of cows' (previous page)

45

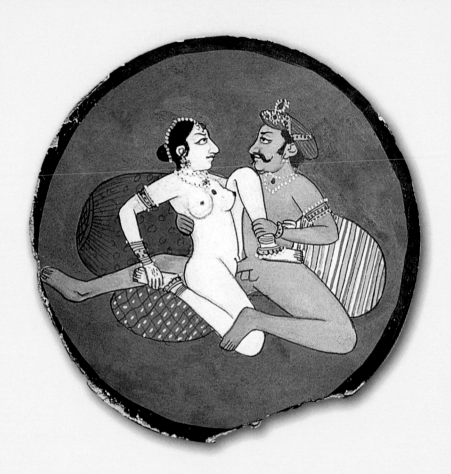

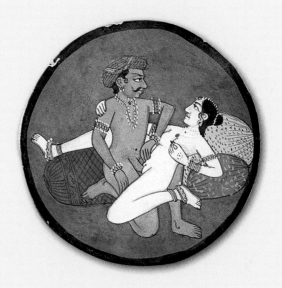

*There are six unequal unions— when the male exceed the woman in size, his union with the woman who is
immediately next to him size is called high union, while his union with the woman most remote from him in size is
called the highest union*

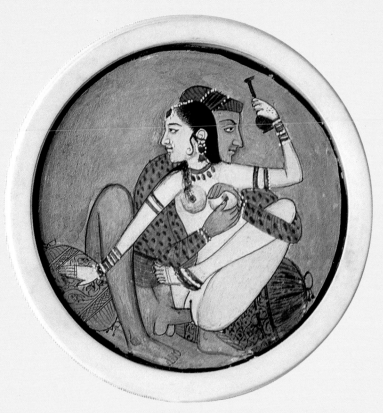

If a man fails to satisfy his lover in an unequal union then a man should concentrate on rubbing and pressing his lover's breasts (above) When lovers support themselves on each other's bodies, and thus while standing they make love, it is called 'supported congress' (facing page)

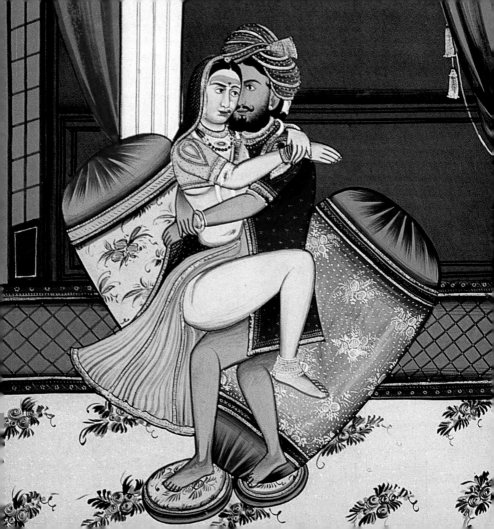

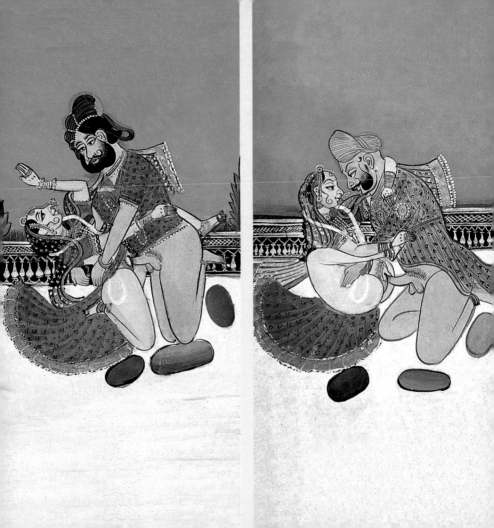

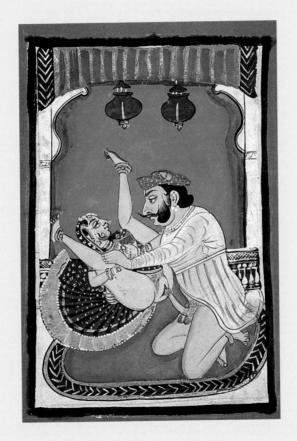

For the male, the horse and mare or the bull and deer form the high union while the horse and mare form the highest union. For the female, the elephant and bull or the mare and hare form the low unions while the elephant and hare and hare make the lowest union

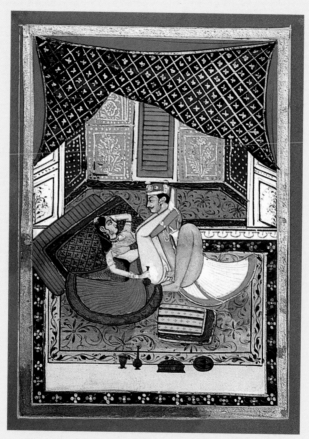

At the first time of sexual union the passion of the male is intense but in the subsequent unions on the same day the reverse is case. With the female it is the opposite for at the first time her passion is weak and her time long, but on subsequent occasions her passion is intense and her time short

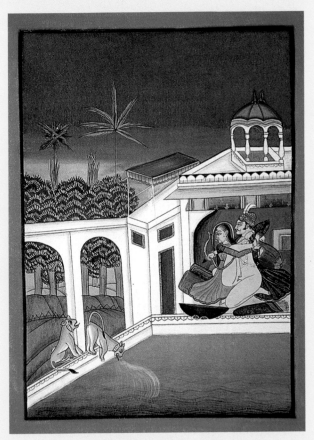

Unions are classified in terms of dimension, force of passion and duration respectively. By using different combinations, innumerable kinds of union can be produced (above) When a woman sees that her lover is tired without having his desire satisfied, she should lay him down and act his part (following page)

53

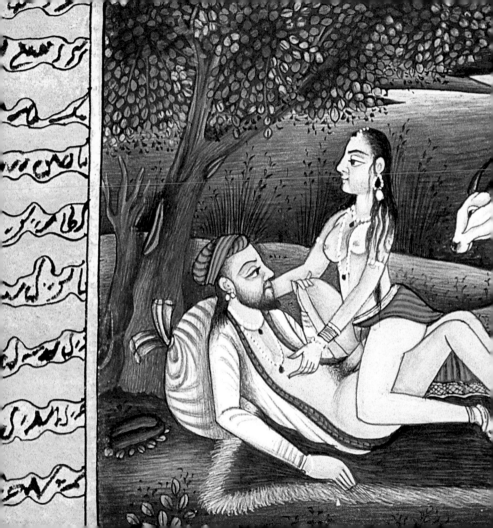

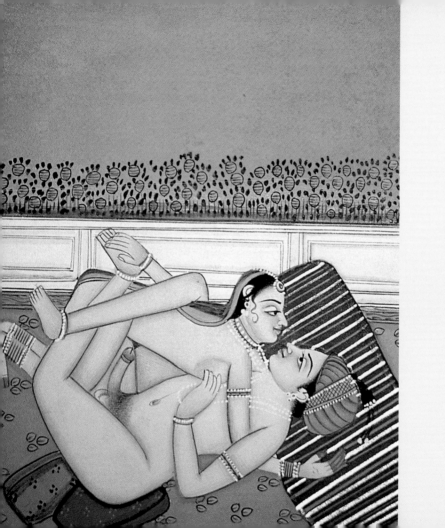

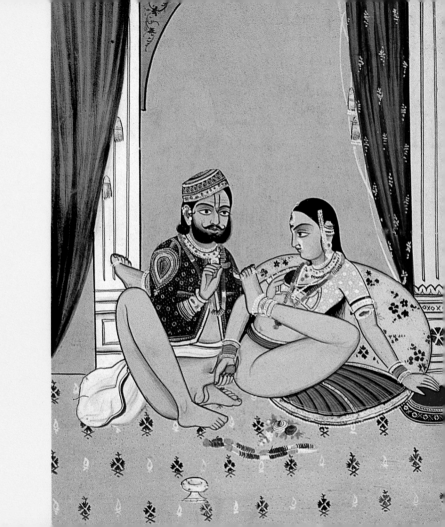

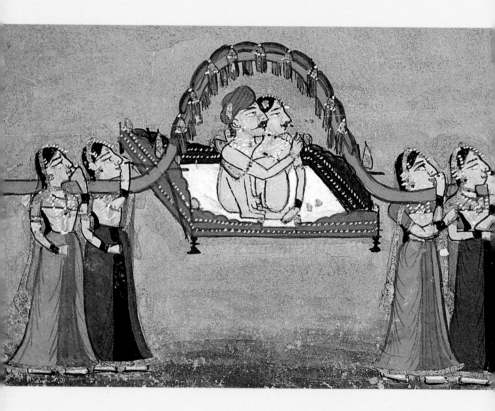

The complicated positions are practiced for total control (above) The woman may act the part of the man to satisfy her desire for novelty (previous page left) The man should anoint his lingam with a herbal mixture to have a hypnotic effect on his partner (previous page right)

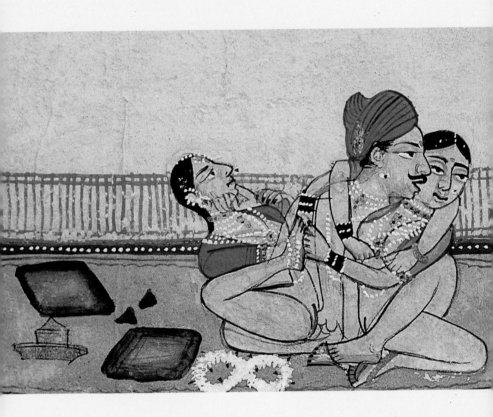

There is no bar on having more than one partner. Vatsayana points out that when a man enjoys two women - both of who love him equally - at the same time is called the state of 'united union' ; conversely, two women can share a man who loves them both

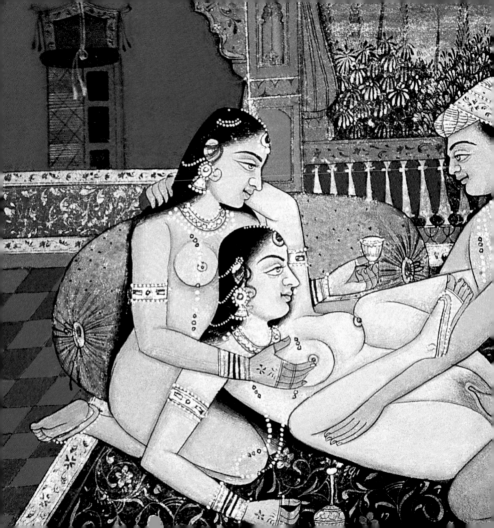

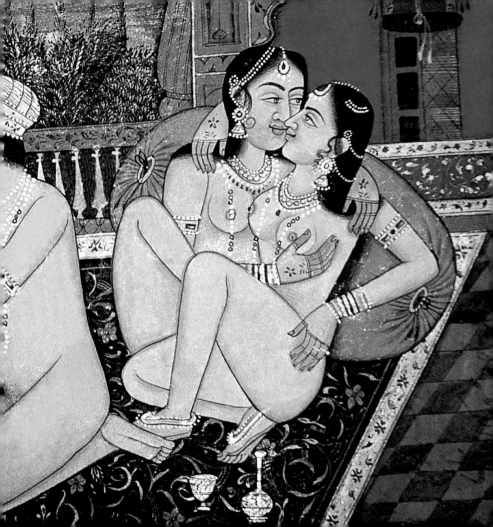

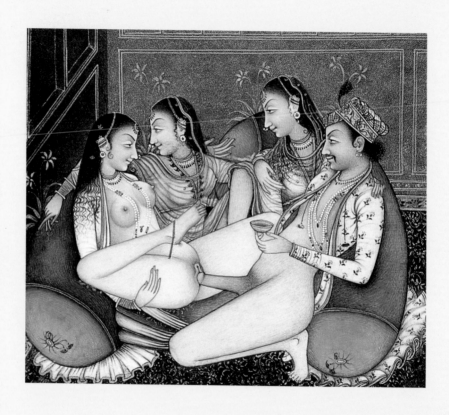

When only one part of the yoni is rubbed with the lingam, it is called the 'blow of the boar'. On the other hand, when the lingam is in the yoni and moved up and down frequently without being taken out, it is called the 'sporting of the sparrow'

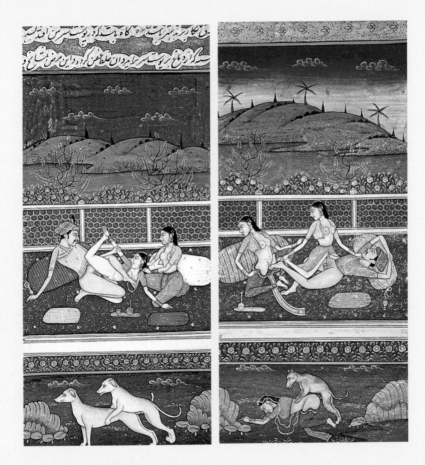

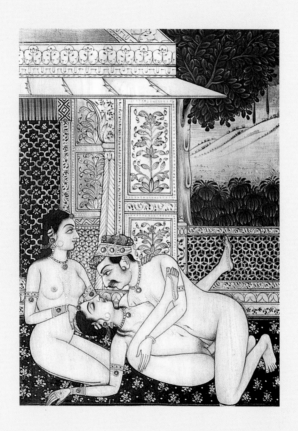